British Museum Objects in Focus

D0433132

The Discobolus
Ian Jenkins

THE BRITISH MUSEUM PRESS

First published in 2012 by
The British Museum Press
A division of the British Museum
Company Ltd
38 Russell Square
London WC1B 3QQ

britishmuseum.org

A catalogue record for this book is
available from the British Library

ISBN 978-0-7141-2271-7

Designed by Bobby Birchall,
Bobby and Co.
Typeset in MillerText and
Berthold Akzidenz-Grotesk
Printed and bound in China
by Toppan Leefung Pte. Ltd

The papers used in this book
are recyclable products and
the manufacturing processes
are expected to conform to the
environmental regulations of
the country of origin.

The registration numbers for the
British Museum objects illustrated
in this book are listed on page 64.
You can find out more about
objects in all areas of the British
Museum collection on the Museum
website at britishmuseum.org

Acknowledgements
The author would like to thank all
those who in various ways have
contributed to the production of
this book. First thanks to Frances
Carey whose idea it was. Thanks to
Emma Poulter and Axelle Russo-
Heath for the editing and picture
research, and to Lesley Fitton who
read and improved the text. Others
that contributed and thus deserve
my thanks are: Charles Arnold,
Celeste Farge, Mark McDonald,
Alexandra Villing, Laura Ware,
Katherine Wilson and Patrick van
der Worst. Not least thanks go to
Sui Jianguo, for letting me see the
Discobolus through his eyes.

Contents

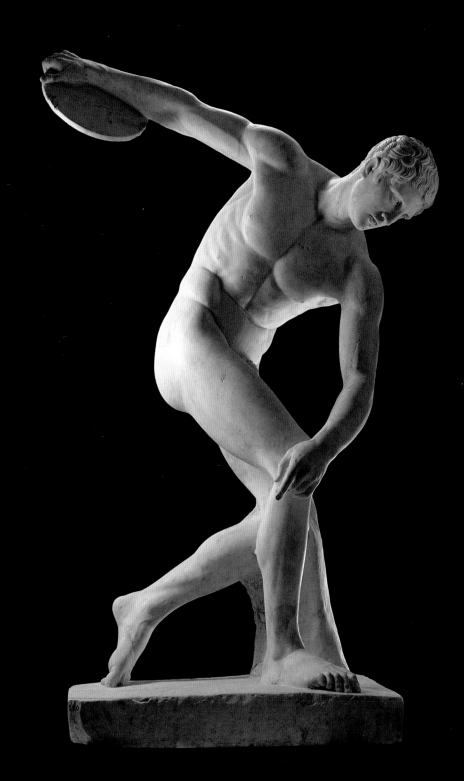

Introduction

1 Myron's Discobolus. Roman marble copy of the lost Greek bronze original. This copy is known as the Townley Discobolus. Italy, 2nd century AD. Height 170 cm. British Museum.

The Discobolus is one of the most famous sculptures to survive from the ancient world. Cast in bronze by the fifth-century BC Greek sculptor Myron, the original discus-thrower has long been lost but, happily, the masterpiece was much admired by the Romans who made numerous copies. The British Museum's copy, the 'Townley Discobolus' (fig. 1), dates to the second century AD and was acquired in 1805 with the collection of Classical sculpture formerly owned by the antiquary Charles Townley (1737–1805).

This little book tells the Discobolus or discus-thrower's story, both ancient and modern, as archaeological artefact and bearer of meaning. In Myron's day it captured Greek ideas about proportion, harmony, rhythm and balance, all of which were sought after in both nature and art. In the modern age it has come to mean different things to different people: to sporting types it is interesting as a representation of ancient discus-throwing; while romantics may view it with melancholy longing for the lost world of ancient Greece. It has been adopted as an exemplar of the male Greek body beautiful, and many internet images invite homoerotic responses. To Nazi Germany, it was a trophy of the mythical Aryan race. On a London transport poster for the 1948 Olympic Games (fig. 37) it was emblematic of the triumph of democratic freedom over fascist tyranny. In the work of the Chinese sculptor Sui Jianguo, dressed in a Mao suit (fig. 38), it could be seen as a metaphor for the intellectual and artistic constraints of communist-era China. Dressed in a business suit by the same sculptor and replicated many times over (fig. 39) it appears to reference Chinese industrial mass production.

Myron's creation is here considered in the context of his other known works and their place in ancient Greek art and society. The story is told of the excitement and controversy surrounding the discovery, identification and restoration of the most famous copies made by the ancient Romans and concludes with the reinterpretations of Myron's masterpiece in the modern age. The narrative ends by reflecting upon the Discobolus' fame, and why it remains a universal icon today.

Myron and his works

Myron was born at Eleutherae, a fortified township on the border of Attica and Boeotia, in Greece. He was a pupil of the sculptor Agelades of Argos, but seems to have worked mainly in Athens around the middle of the fifth century BC. From his teacher, Myron would have learned the complex and physically demanding processes of casting bronze. A life-size human figure such as the Discobolus would have been hollow cast in several segments that were subsequently joined together. The joins would be smoothed out as part of the finishing stage, which also included the colouring in contrasting metals of such details as the nipples and lips. Particular attention was paid to the eyes where ivory, glass and semi-precious stone might be used. The hair was often worked in elaborate coiffures, but the Roman author Pliny the Elder (died AD 79) says that this was not the case in Myron's Discobolus, where the head and pubic hair were done in the manner of much earlier bronzes, as demonstrated in what is known today as the Lancellotti copy of Myron's original (figs 7 and 27). To judge from the head of this statue, which will be discussed further on pages 40–41, this probably meant close-cropped hair, and without the elaborate attachment of individual locks, as was sometimes done.

Technique could be learned, but Myron stood apart from the crowd by virtue of his great gift for breathing life into his work. He was especially famous for his animal sculptures. Pliny mentions a dog and, curiously, a memorial to a pet locust and a cicada. It was for his bronze cow, however, that Myron was best remembered by the Romans. It probably stood on the Acropolis of Athens and may well have been the inspiration for the sensitive portraits of cattle being led in procession on the Ionic frieze of the Parthenon. In the Roman period, Myron's cow was the subject of many epigrams praising its truth to nature. A typical example is:

> In this cow Nature and Mistress Art did compete
> And Myron awarded the prize to both.
> To those who have seen it, Art has deprived Nature

But to those who have touched it,
Nature remains Nature.
(*Greek Anthology* 9.738, Julian of Egypt)

Roman fascination for the works of Myron has partly
to do with the fact that some of them were actually to
be found in Rome. The Roman writer Strabo recalls (in
Geographica 14.1.14), a group of three colossal figures by
Myron that had once stood on the sacred way leading to
the Temple of Hera on the east Aegean island of Samos. It
comprised the hero Herakles in the company of the Greek
god Zeus and goddess Athena. The subject must have been
the introduction of the hero to Zeus by his patron deity
Athena following the successful completion of the twelve
labours. The Roman General Mark Antony is said to have
carried the sculptures off as a trophy, but the emperor
Augustus restored two of them to their original base, while
the Zeus he transferred to the Capitol of Rome.

Group sculpture seems to have been a speciality of
Myron, provoking a set of responses based upon the
viewer's own knowledge of Greek myth. The entry of
Herakles into Olympus reminded the spectator of his
twelve labours and conveyed the moral message that
fortitude and perseverance in the face of adversity win
out in the end. Myron's Athena and Marsyas (figs 2 and 3)
displayed on the Athenian Acropolis told a very different
story from that of Herakles and carried an entirely
different moral message. The myth was one of a type
warning mortals against the folly of overarching ambition
that was likely to attract the wrath of the gods. The
mythological character Niobe, for example, was destroyed
along with her children for boasting of their beauty. Then
there was Arachne, turned into a spider for daring to
challenge Athena, goddess of spinning and weaving, to
a contest.

The story of Marsyas relates how in her youth Athena
is credited with the invention of the *auloi* or double-pipes.
These unusual instruments were reed blown like the
modern oboe and required subtle breath control. Catching
sight of her reflection in a pond, the goddess was appalled

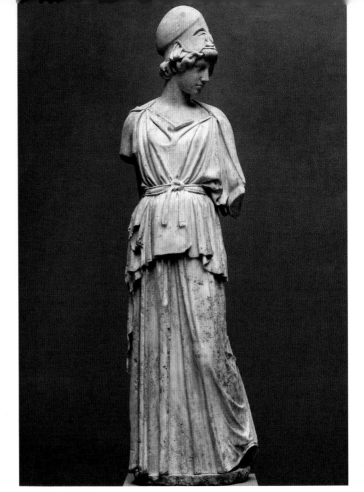

2 and 3 Athena (left) and Marsyas (right). Roman marble copies of the lost original bronze group by Myron. Italy, 5th century BC. Height 173 cm and 159 cm respectively. The Liebieghaus Museum, Frankfurt and Vatican Museums, Rome.

by the manner in which her cheeks puffed out and distorted her face and she tossed the pipes away in disgust. At this point she was taken by surprise when the satyr Marsyas sprang forward and, picking the pipes up from the ground, pressed them to his own lips. This horse-tailed follower of Dionysus, god of wine, produced such beautiful sounds from the *auloi* that he was moved to dare Apollo, god of music, to a contest. The Muses were appointed as judges and, not surprisingly, they declared Apollo, their divine master, the winner. Apollo cruelly punished Marsyas for his folly by having him flayed alive. In the tragic theatre of Myron's Athens violent acts such as the murder of

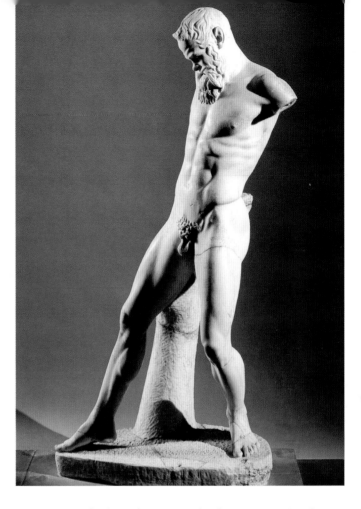

Agamemnon by his scheming wife Clytemnestra in *The Oresteia* by Aeschylus, or the self-blinding of Oedipus in *Oedipus the King* by Sophocles, were committed off stage, away from the gaze of the audience. In a similar manner Myron spared his spectators the horror of Marsyas' death and showed instead the moment of confrontation with Athena. The sculptor relied upon his public having prior knowledge of the Marsyas story in order to set up a visual and intellectual correspondence between viewer and sculpture.

Given his liking for paired or grouped subjects, it is possible that Myron's Discobolus was coupled with

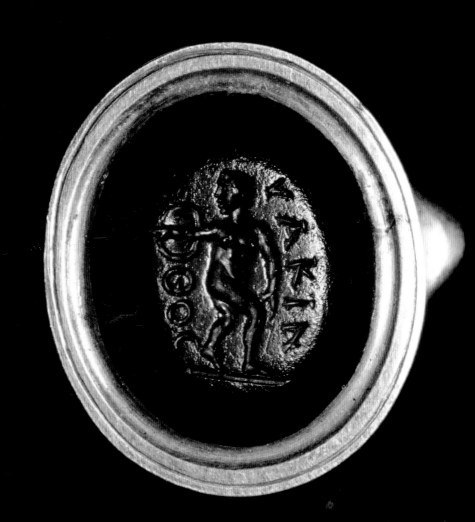

4 Nicolo sealstone engraved with an athlete, inspired by Myron's Discobolus and inscribed *Yakinthos*. **Roman, 2nd century AD. Length 1.3 cm; width 1.1 cm. British Museum.**

another subject. A coarsely engraved sealstone in the British Museum (fig. 4) reproduces a figure posed roughly in the manner of Myron's athlete. The background is inscribed *Yakinthos*. This is a reference to a story that would be comical, if it were not so tragic. The beautiful boy Hiacynthus, who gave his name to the fragrant flower, was accidentally killed by an ill-aimed discus thrown by his lover, the god Apollo. One version of the myth says that the discus was blown off course by Zephyr, the West Wind, whose own amorous approaches to Hiacynthus had been rejected in favour of Apollo's. Was there a group of Zephyr, Apollo and Hiacynthus practising the discus? Like the Athena and Marsyas, such a narrative group would have been pregnant with the knowledge of what came next. Pliny mentions an Apollo by Myron,

> . . . taken off by the Triumvir Antony, but restored again by the deified Augustus after he was warned in a dream.

Another possibility is that the Discobolus was a single figure composition representing Hiacynthus alone. The cult of Hiacynthus originated with the Spartans who worshipped him at the sanctuary of Amyklai in the western Peloponnese. It is thought to have played a part in a cycle of rites of passage for youths preparing for life as a Spartan soldier.

One more possibility is that the Discobolus was commissioned to commemorate an athlete's victory at one of the great festival games. By the Roman period the sanctuaries of Olympia, Delphi and the other Greek festival sites bristled with the commemorative monuments of past victors. Myron executed numerous single figure subjects for this purpose and the discus-thrower may have been one of them.

Finally, the Discobolus may have been a creation of Myron's own choosing, conceived by him to exemplify his own theory of male beauty in sculpture.

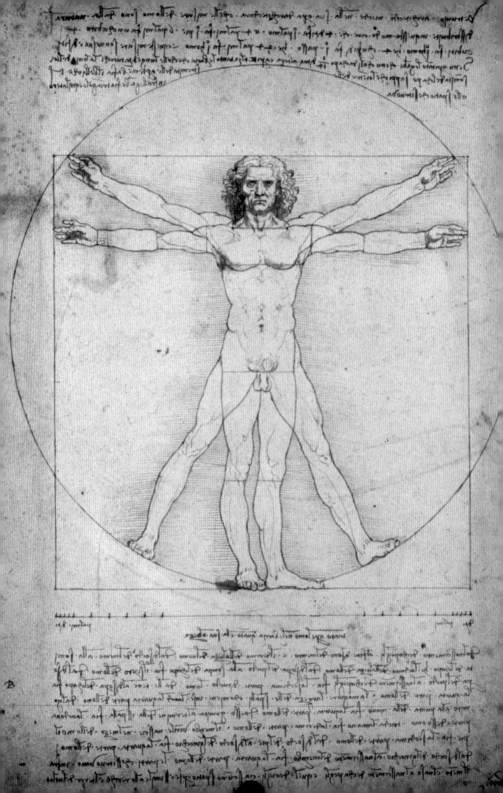

Body and mind

A constant theme in Greek natural philosophy and one that is embodied in Myron's Discobolus is the quest to find a permanent and measured order behind the ostensible chaos of the world. Order in the material world was often explained in terms of a balance of opposite forces such as the strong and weak, wet and dry, hot and cold and so on. Philosophers could be mathematicians too and in the sixth century BC Pythagoras' discovery of the measurable intervals of the tonic scale in music was taken as confirmation that numbers were the stuff of reason and had the power to illuminate the dark mysteries of the universe.

Greek philosophers of all periods retained a fascination for the natural world but in the fifth century BC they increasingly focused on ethics, on human character, belief and behaviour. Athens became the centre of Greek moral philosophy and it was there that humanity's modern sense of self was first forged. Myron's contemporary, the philosopher and teacher, Protagoras, famously said:

> Man is the measure of all things,
> of the existence of what exists,
> and of the non-existence of what does not exist.

These words have resounded down the ages as a key humanist text. The first-century BC Roman architect Vitruvius clearly had it in mind when he devised a system of architectural proportions correlated to parts of the human body. This was later illustrated in Leonardo da Vinci's iconic drawing, *Vitruvian Man* (fig. 5).

As a leading figure in Athens' golden age, Myron set out to develop the human body as both a physical and moral being. In the sixth century BC the *kouros* type of male sculpture had served the same purpose. With arms held stiffly by the sides and weight placed equally on both legs, the *kouros* had provided a figure type which served formulaically to represent the *kalokagathia* of a well-born young man, that is to say one who is 'fair of face and sound of heart'.

Early in the fifth century BC, having served its purpose for

a century or more, the *kouros* was abandoned in favour of a more naturalistic figure type that placed the weight on one leg. A turn of the head and the raising of one or both arms would intensify the illusion of sculpture as a living body.

The more advanced fifth-century BC sculptors worked in bronze. The loss of the greater part of their output makes it near impossible to assess their work accurately. Roman marble copies can give an idea of the broad outlines of a figure, but do not convey the subtle surface modelling and atmosphere or finish of the bronze original. Chance survivals of Greek bronzes are rightly celebrated but they also inspire melancholy as reminders of what is lost. One of the most lamented of all such lost bronzes is the Doryphorus or spear-bearer of Polyclitus of Argos. Cast around 440–430 BC, it also goes by the name of a treatise, the Canon. This was written by the sculptor to explain the carefully calculated set of measurements that were applied to every element of the sculpted body. The length, for example, of one finger was measured in proportion to the length of the whole hand, which in turn was calculated in relation to the forearm and so on.

A reconstruction of the spear-bearer in bronze, and made up of parts copied from more than one source, was created by the German sculptor Georg Römer around 1920 (fig. 6) and installed in a public area of the main university building in Munich. This was severely bomb-damaged in World War II, and it is often assumed that the replica was destroyed at this time. However, although it lost its spear and also the eyes, the figure survived intact. It gives a good idea of the composition of the Canon, arranged as a collection of opposite motifs. The right leg bears the weight, while the left is weight-free. The left arm is bent at the elbow to hold a spear, while the right arm hangs with the hand empty. The right hip is tilted up and the other is lowered. Polyclitus' Canon was an attempt to set the absolute standard of male beauty, arithmetically calculated and artfully composed. The Canon exemplified not only the physical aesthetic of the young male athlete but also the moral virtue of one who is capable of acquiring *timé* (honour) and, ultimately, *areté* – that human condition

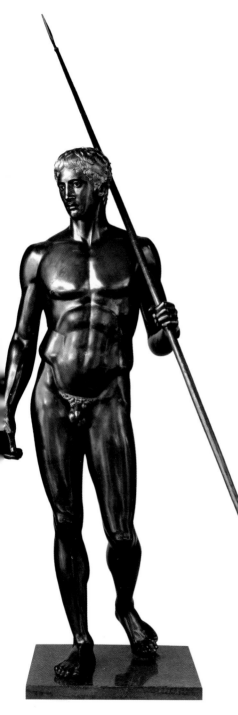

inadequately translated as 'excellence'. Just as Myron's discus-thrower may be the youth Hiacynthus, so the Canon is perhaps legendary Achilles, tragic Greek hero of the Trojan War. While Myron's creation is undeniably an athlete, Polyclitus' is not carrying the light throwing spear or javelin, but the heavier thrusting lance or *doru*.

Pliny may well have had these two sculptures in mind when he wrote that Myron was more inclined to use patterns in the composition of his sculptures and more fastidious in his use of measured proportion. Given that both sculptors trained in the workshop of Ageladas of Argos, it is safe to assume that Polyclitus knew the work of his older contemporary Myron. Indeed, in devising his Canon, Polyclitus probably had in mind the Discobolus and set out to trump its creator with his own version of conscious pattern-making (*rhythmos*) and commensurability (*symmetria*).

As previously mentioned, the compositional scheme of the Doryphorus is based upon a system of opposites. It is interesting to remark, however, that the same principle is to be found in the main view of the Discobolus (fig. 7), where one arm extends behind gripping the discus, while the other arm hangs free with the empty left hand brought in front of the right knee. The torso is turned to face the viewer, while the buttocks and legs are seen in profile. One leg bears the weight, while the other is weight-free. The toes of the right,

engaged leg arch upwards, while those of the other leg curl under.

This Yin and Yang of the Greek male body is carried even – as Roman critics were to remark – to the point of forcing the torso into an unnaturally contorted pose. The result is a design that is contained within a narrow plane as if this were a relief sculpture rather than a figure carved in the round. The composition can be traced in two simple outlines, as shown in figure 7. The first describes an arc that runs from the discus, down the outstretched arm through the head and down the hanging arm to the weight-bearing leg. The second complementary line zig-zags down the underside of the outstretched arm, down the right flank to the weight-free leg. Together these two lines resemble the wood and string of a bow and bring to mind the ancient saying *Bíos Biós*, 'Life is a bow'. The word in ancient Greek can mean both, depending upon which vowel is stressed.

A comparable illusion of arrested movement can be found in the Doryphorus of Polyclitus (fig. 6). With one leg forward and weight-bearing and the other trailing behind and weight-free, the figure appears to be caught mid-action, transferring the body weight from one leg to the other in the act of strolling. This clever device is common in Greek sculpture and was anticipated by the rather more stylized and formulaic composition of the archaic *kouros*, which statue type has the weight on both feet. The Egyptian counterpart places the weight on the back leg only, thus rooting the figure firmly to the spot. The principal intended view of Myron's Discobolus is surely that shown in figure 7 and is that which the ancient commentators had in mind in mentioning its compositional patterns (*rhythmoi*). It is sometimes said that this view of the Discobolus is the only one that makes any sense and that when it is viewed end on, as in figure 8, the composition loses all coherence. It is said to become an untidy jumble of arms and legs without design or purpose. But this is not so. Viewing the sculpture from other viewpoints releases it from the constraints of Myron's academic exercise in formal composition and returns the figure, as it were, to nature.

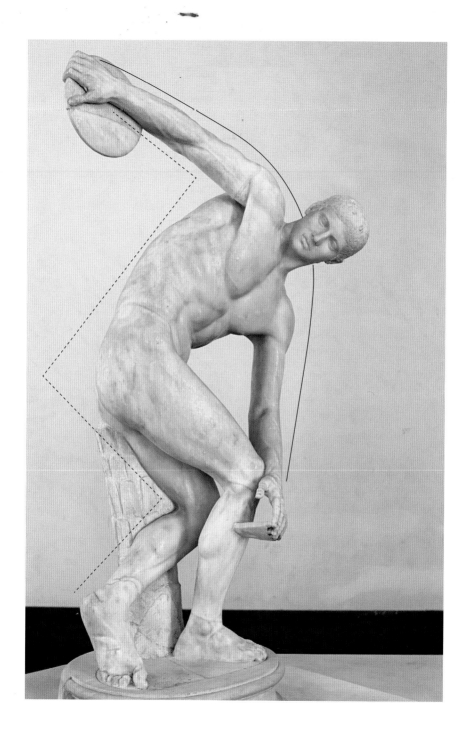

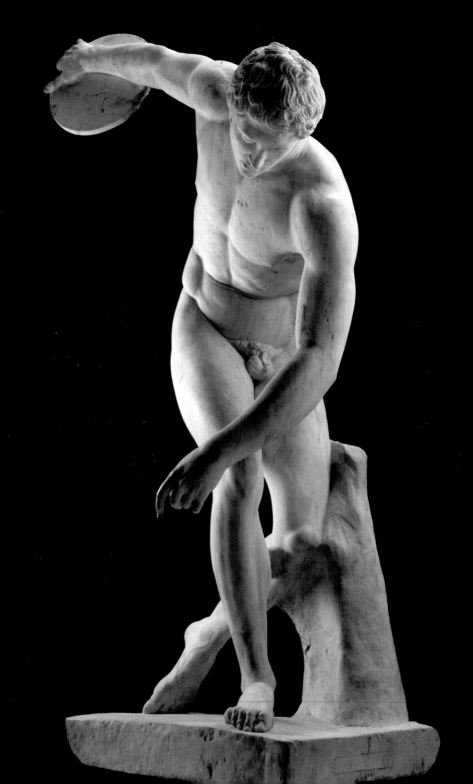

8 Left (and detail right) The less familiar views of the discus-thrower show the figure more naturalistically than the rigidly conceived composition of balanced opposites shown in fig. 7.

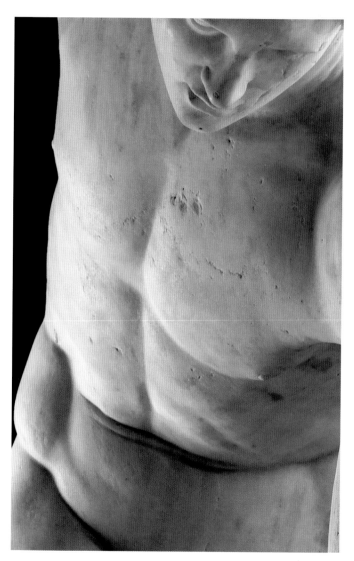

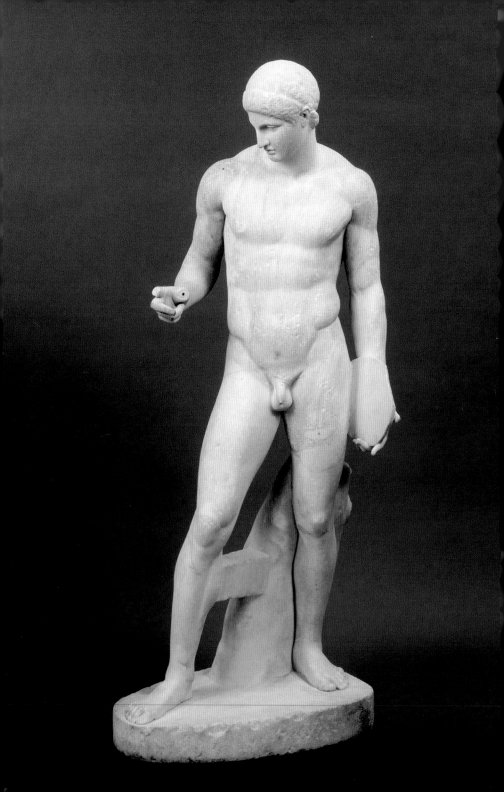

Discophorus

9 The Discophorus attributed to Naukydes, a follower of Myron. Roman marble copy of a lost Greek bronze original. Italy, 2nd century AD. Height 167 cm. British Museum.

The Roman author Pliny the Elder mentions a discobolus by Naukydes of Argos, a sculptor who worked around the last quarter of the fifth century BC. This discobolus is usually identified with a figure represented in several surviving marble copies which does not throw the discus but holds it by his side (fig. 9). Although Pliny uses the word discobolus, the term discophorus or discus-carrier might be more appropriate. The relaxed pose with the weight supported on one leg, together with the contemplative composure of the head turned down and to one side, capture the moment when the athlete gathers himself before beginning the series of movements that will launch the discus into the air. This static composition contrasts with Myron's dynamic figure and was perhaps deliberately intended by Naukydes (if indeed it was he) to compete with the earlier master's work.

Charles Townley (1737–1805)

The second-century AD Roman emperor Hadrian was an admirer of all things Greek. His pleasure park at Tivoli, east of Rome, once boasted great quantities of statuary often copied in marble from Greek originals. In the eighteenth century of the modern era the excavation and restoration of such Roman replicas fed a thriving market for all things Classical which could lead to fierce rivalries and bidding wars among collectors. The trade was legal and subject to control by the Pope's own antiquary, who dictated what should go and what should stay and arranged for the issue of export licences. Many of these sculptures were bought by English gentry, who installed them in their country houses, where in some cases they remain to this day. More rarely they were exhibited in fashionable house-museums in London, such as that of the important antiquary Charles Townley.

Travel in Italy was an indispensable part of a wealthy young man's education in the age of the European Enlightenment. Townley made three separate visits, and during the first in 1768 he immediately established

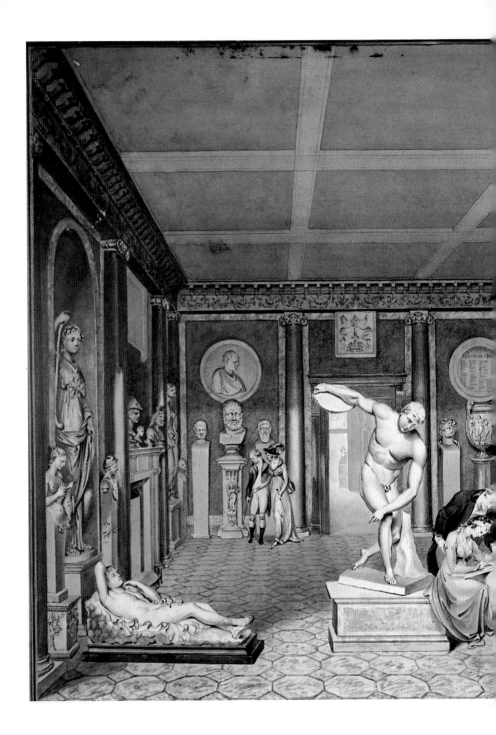

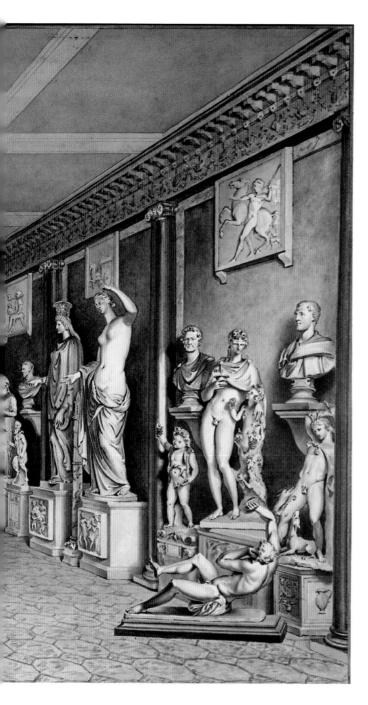

10 Dining room of Charles Townley's house, 7 Park Street, Westminster, with the newly acquired Discobolus. Pen, ink and watercolour drawing by William Chambers, 1794. 39 cm x 54 cm. British Museum.

himself as a determined collector of antiquities. Back in England, Townley corresponded with the dealers whose acquaintance he had made in Rome. These were principally the painters turned antiquaries, Thomas Jenkins (1722–1798) and Gavin Hamilton (1723–1798). With their help he was to assemble one of England's foremost collections of Classical sculpture, artfully displayed at 7 Park Street, Westminster.

Of all the sculptures assembled in Charles Townley's town house, the marble Roman copy of Myron's lost masterpiece in bronze is surely the most famous. Purchased from Jenkins for £400, the Discobolus was the last major acquisition of sculpture that Charles Townley was to make. It arrived in 1794 and was prominently displayed in the dining room, where it was included in one of two drawings of Townley's house-museum by William Chambers (fig. 10). A more fanciful depiction of Townley's ménage is the celebrated portrait by Johann Zoffany (fig. 11). Having largely completed the picture by 1790, the artist returned to his canvas in 1798 and added the Discobolus to the bottom left corner of the picture. There he seems to be watched by Kam, Townley's favourite dog, in the eternally vain hope that the athlete might one day release his projectile.

Upon his death in 1805, the Townley collection of sculpture came to the British Museum. In 1814, through his kinsman Peregrine Towneley [sic.], the Museum acquired Charles Townley's other antiquities, including bronzes, Greek vases, terracottas, Roman lamps and engraved sealstones. Also acquired at this time was his collection of drawings illustrating his own and other collections. Finally, in 1992 his archive of letters and other documents was purchased. Taken all together, this collection provides a unique insight into the world of an eighteenth-century connoisseur.

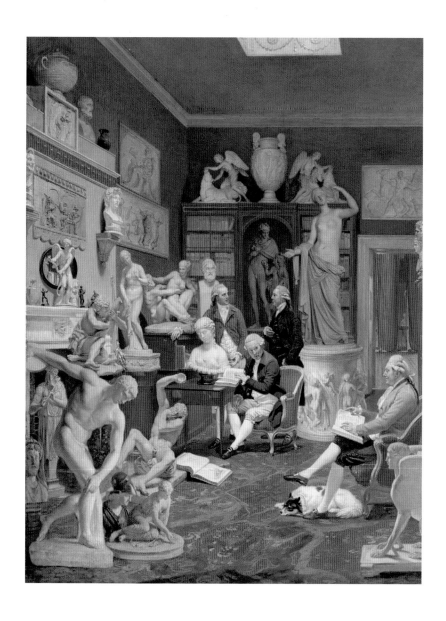

Maximius
Discobus

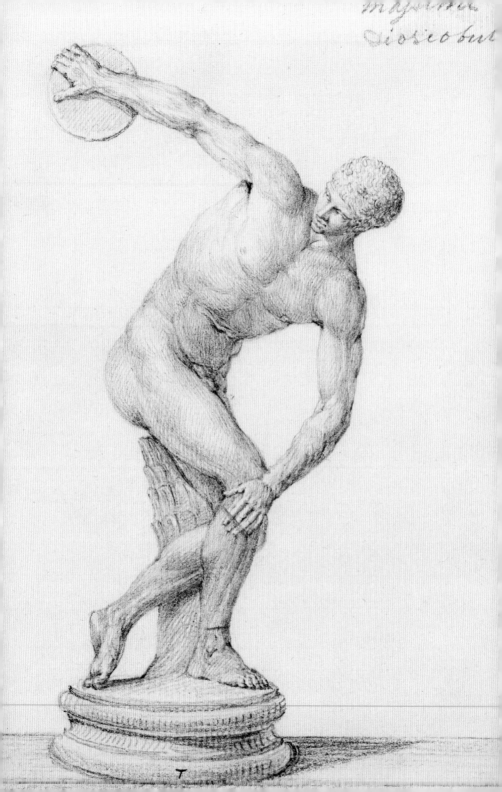

The Lancellotti and other Roman copies of the Discobolus

Charles Townley's interest in Myron's statue had been kindled some ten years before he embarked upon the purchase negotiations for his very own version of the discus-thrower. On 24 March 1781, Thomas Jenkins had written: 'In the Villa Polombaro near Santa Maria Maggiore, the Marchese Massimi has just found a fine statue of a discobolus in great preservation and an action quite new . . .'. Jenkins was referring to the statue today known as the Lancellotti Discobolus, first displayed in the Palazzo Massimo delle Colonne, and later removed to Palazzo Massimo Lancellotti, both in Rome. Gavin

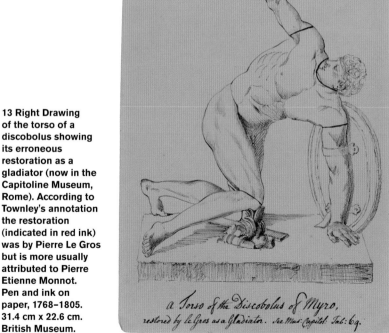

a Torso of the Discobolus of Myro, restored by le Gros as a Gladiator. see Mus: Capitol: Tab: 69.

27

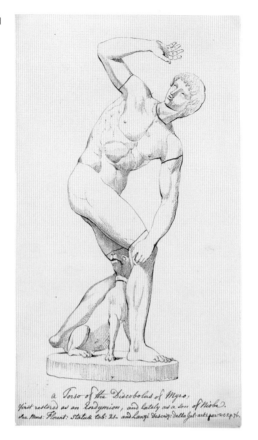

14 Drawing annotated by Townley of a torso of a discobolus wrongly restored as the moonstruck Endymion. Restored areas are marked in red ink. Pen and ink on paper, 1768–1805. 35.7 cm x 20.3 cm. British Museum.

a Torso of the Discobolus of Myro, first restored as an Endymion, and lately as a son of Niobe. dna Mus: Florent: Statua tab: 21- and Lanzi doscriz: delle Gal: art: par: 2 c: 5 p: 76.

Hamilton sent a sketch by Tommaso Piroli, which is perhaps that shown in fig. 12. The artist is better known for his printmaking after old master paintings. Townley was to put together a dossier of such drawings relating to Myron's Discobolus.

Before the Lancellotti version was found complete with its head, fragmentary torsos of ruined discoboli were unrecognized and were therefore restored without knowledge of how the original composition was meant to be. Examples of especially fanciful restoration are illustrated by three anonymous drawings from Townley's archive. They include a fallen so-called Gladiator in Rome's Capitoline Museum (fig. 13).

Another drawing shows a discobolus that had at first been

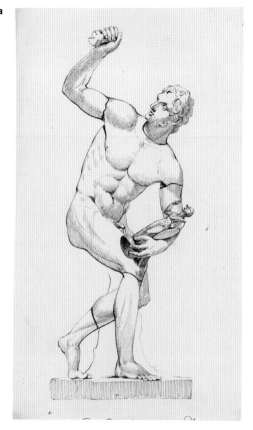

15 Drawing showing a torso of a discobolus wrongly restored as Diomedes carrying off the Palladion (statuette of Pallas Athena). Restored areas are marked in red ink. Pen and ink on paper, 1772–1805. 35.7 cm x 20.5 cm. British Museum.

restored as the mythological character Endymion, blinded by the moon (fig. 14). In a subsequent restoration the dog was cut away from this statue so that it could become one of the sons of Niobe (whose boastful pride of the beauty of her children provoked divine vengeance) and so join the famous group of Niobids in the Uffizi Palace in Florence.

A third drawing (fig. 15) shows a version restored as Diomedes, one of the heroes of the Trojan War, with the Palladion (statuette of Pallas Athena) in one hand, turning back with a dagger in the other. This had been sold by Gavin Hamilton to the second Earl of Shelburne. It had been found at Ostia, the port of ancient Rome, in 1772. Figure 17 is a photograph of the Diomedes statue.

Lord Shelburne was to become the first Marquess

29

of Lansdowne in 1784 and the Lansdowne collection of marble sculpture rivalled that of Charles Townley. Lansdowne House, built by Robert Adam, the leading neo-classical architect of his day, was one of the principal house-museums of London. Sadly, in 1930 the collection was sold and dispersed, while the House was partially demolished to create a road leading from Berkeley Square to Piccadilly. The few sculptures that did not sell in the auction of 1930 were transferred to the family's country home at Bowood House in Wiltshire. The Diomedes was

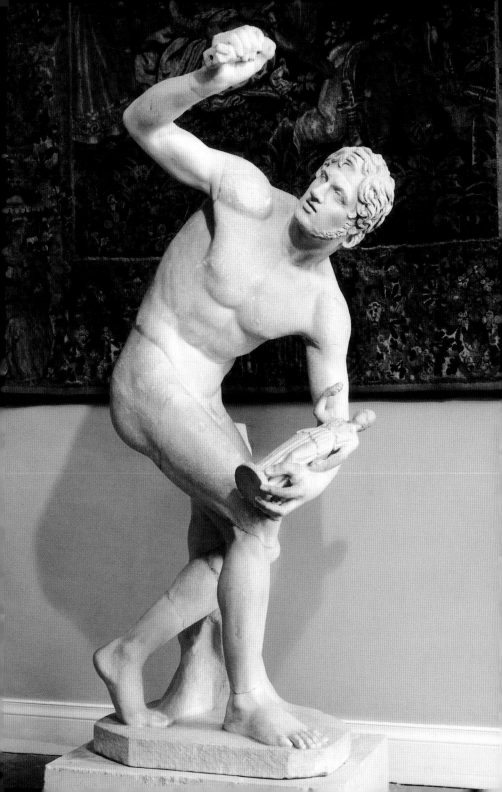

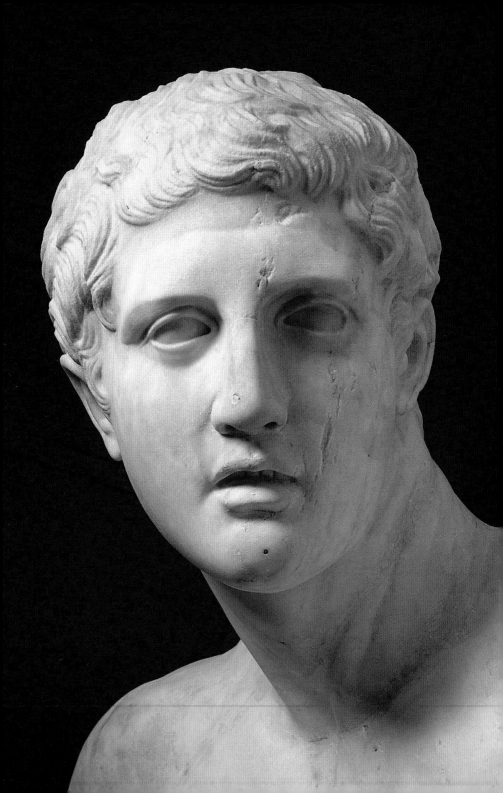

one of the sculptures that did not find a buyer in 1930, no doubt because its eighteenth-century restorations were too obviously wrong. Not only are the arms and legs restored, but also the head, if ancient, is not part of the same statue.

There was a natural rivalry among the London collectors, who were all clients of the same dealers in Rome. Townley, however, was never in the running to buy the Diomedes and indeed he knew nothing of it until he received a letter from Hamilton declaring its sale to Shelburne as a done deal. An image was sketched in the letter itself and is a rare autograph drawing by Gavin Hamilton (fig. 16). Townley did well to wait for his discobolus, which was found after the discovery in 1781 of the Lancellotti version and was therefore correctly identified, if not correctly restored.

The Townley Discobolus

Townley's sculpture is said to have been restored by Carlo Albacini, the most successful pupil of the great eighteenth-century sculptor and restorer, Bartolomeo Cavaccepi. For the most part the statue is ancient, with some minor restorations to the discus, limbs, toes and fingers. The head, however, while ancient, does not belong, even though Jenkins was to maintain throughout the purchase negotiations that it was the original and insisted that it was found lying next to the body.

The attachment of an alien head to the Townley Discobolus (fig. 18) necessitated its being wrongly placed to look forward instead of back (fig. 1). This contradicts the Lancellotti version (fig. 7) which, as we have seen, was known since 1781. There is also the description of the second-century AD author Lucian, which explicitly says that the head of Myron's statue was turned towards the discus.

Only one side of the correspondence covering the purchase negotiations for the Discobolus survives, namely that of Jenkins to his customer. Townley, however, was not the only client whom the dealer notified of the purchase opportunity and Jenkins kept up a parallel exchange of letters with the Marquess of Lansdowne. Besides the Discobolus, there was mention of a Herakles. Townley played hard to get at first and seemed reconciled to both

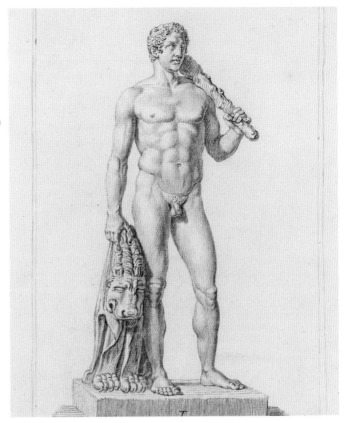

statues going to Lansdowne. Besides, in a letter dated 7 March 1792, Jenkins wrote to say that the Pope had refused an export licence for the Discobolus, 'alleging that it is in a style much superior to that of the Massimi [Lancellotti] and corresponds most exactly to that mentioned by Pliny on the work of Myron.' Jenkins piled on the pressure. In a follow-up letter dated 17 March, he explained how the Pope was annoyed that his sculptor, Giovanni Pierantoni, had not secured the Lancellotti version, for which His Holiness was said to have offered Massimi 2,000 crowns, about £480.

Jenkins' report was no doubt intended to provoke in Townley a yearning for an object that he did not know he wanted until he was told he could not have it. This, after all, can be a recurring nightmare of the serious shopper.

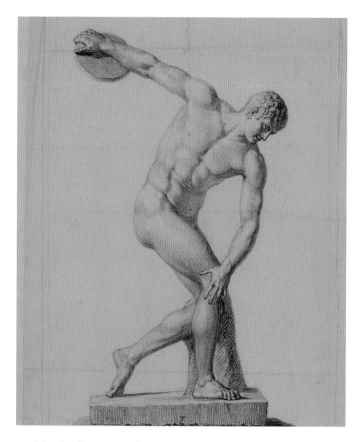

Jenkins had promised drawings of both the Herakles
and the Discobolus, and these finally reached Townley in
a letter dated 31 March 1792. Remarkably they survive
(figs 19 and 20) and can be safely attributed to Vincenzo
Dolcibene, who was then Jenkins' favourite draughtsman.
A letter at Bowood House, dated 3 April 1792, records
the fact that Townley had shown these drawings to
Lansdowne. The Marquess would take the Herakles while
Townley at last declared in a letter to Jenkins dated 24 July
1792 that he would accept the Discobolus.

On 1 September 1792, Jenkins brought Townley up
to date on the still withheld export licence. The dealer
remained confident of the sculpture's eventual release and
even began to prepare his client for its arrival in London.
Jenkins was concerned that Townley's connoisseurial eye

21 and 22 Back view of the Townley Discobolus and detail of the head in profile.

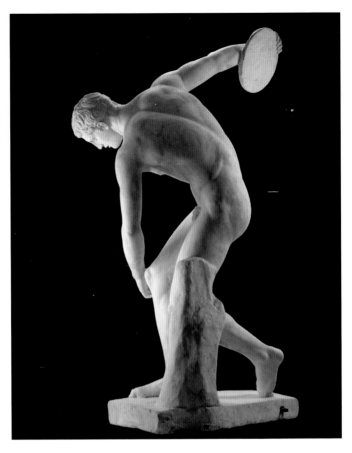

could hardly fail to notice that the statue had lost 'la pelle sua', 'its own skin'. After its discovery the surface had been washed but was still coated in an excavation crust. This was removed with aquafortis or nitric acid, sand and a brush, a common practice and one which most collectors would not even have noticed. Townley, however, was more discerning.

In a letter dated 21 November, Jenkins wrote to say that the long awaited export licence for the Townley Discobolus had just been issued. Tivoli, ever obliging, had unexpectedly yielded a second discobolus and to everyone's satisfaction, there were enough to go round! The new find (fig. 24) lacked the head, which loss was remedied by copying the alien head attached to the Townley version.

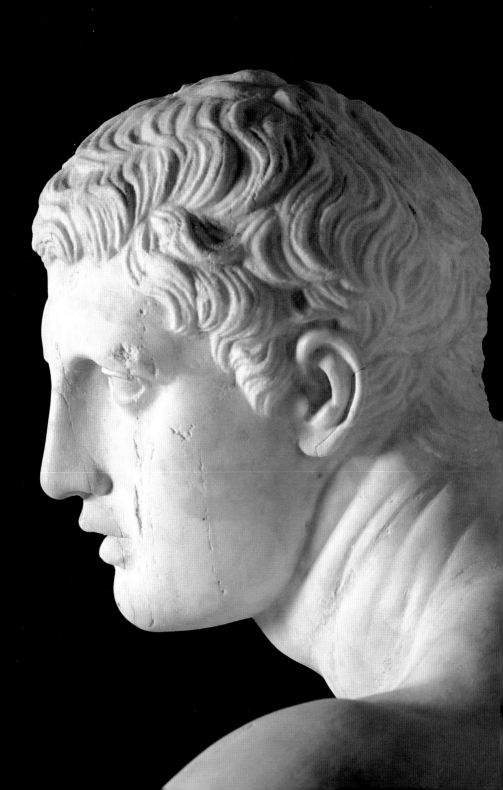

Purists may view this as adding insult to injury but it nicely illustrates the degree to which the restoration of Townley's Discobolus was accepted by his contemporaries.

The discovery of yet another discobolus was not the only reason for the Pope's change of heart. The sudden release of the permit was also occasioned by fear of a French invasion and the consequent need for the Vatican to cultivate Britain as an ally. To quote Jenkins:

They look upon England as the only power that can check the extension of French principles and conquest and

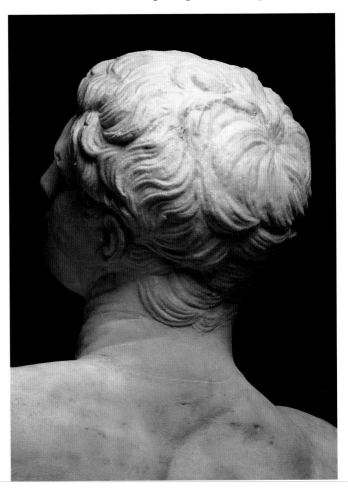

23 Detail of the back of the head and shoulders of the Townley Discobolus.

Prince Augustus being lately arrived has so flattered his holiness that at this instance there is scarcely anything he would not do to prove his desire to please the English.

The Catholic tendency of the sixth son of HM King George III was to land the prince in trouble. Augustus became estranged from his father when the King declared his Catholic marriage void. By invoking the prince's name, Jenkins was of course aware that Townley was himself a Catholic. The Pope's fears were well founded. The occupation of Rome by French forces in 1796 saw the

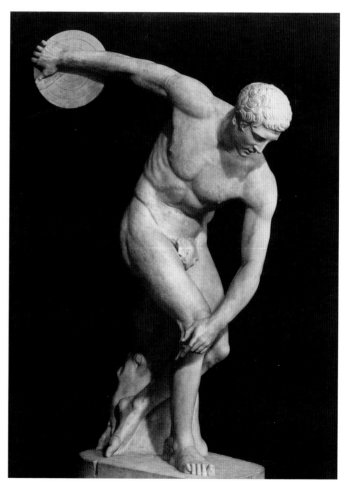

24 The Vatican Discobolus with head restored copying the Townley version. Roman marble copy of Myron's lost bronze original. Italy, 2nd century AD. Height 155 cm. Vatican Museums, Rome.

transfer from Rome to Paris of many Vatican treasures. They included the Vatican Discobolus (fig. 24), which was exhibited in the Louvre in Paris at the end of the Hall of the Laocoon.

When finally his purchase arrived, Townley was disappointed. In spite of all Jenkins' efforts to talk up the Discobolus, the collector felt that he had made the wrong choice and should have gone for the Lansdowne Herakles

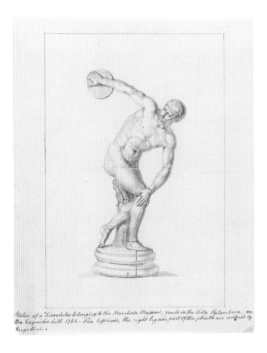 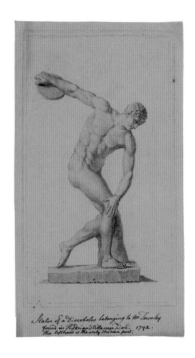

25 and 26 Vincenzo Dolcibene's drawings of the Lancellotti Discobolus (left) and the Townley Discobolus (right), with restored broken areas indicated in red. Black chalk on paper, 1794. 25.7 cm x 20.2 cm and 33.9 cm x 19.5 cm. British Museum.

instead. Townley had evidently written complaining to Jenkins, who replied with three sketches (two of which are shown above) all by Dolcibene, of three discoboli, the restorations marked in red. The restorations of Townley's version were made to seem minimal but should have included the head and a slice in the neck, a piece of the right leg and parts of the toes and plinth.

Jenkins launched an attack on the Lancellotti Discobolus which, he said, was in a 'very unfinished style'. He goes on,

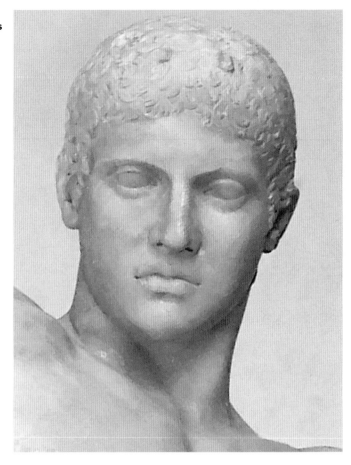

27 Head of the Lancellotti Discobolus (see fig. 7 for full view), with two horn-like knobs where the hair remains unfinished. Museo Nazionale, Rome.

The action of the head, as you will see by the sketch is rather too much forced. The left hand, right leg and part of the plinth were restored by Giuseppe Angelini. The statue altogether is certainly much inferior to all others found of that subject.

There is some truth in Jenkins' admittedly self-interested account. The hair of the Lancellotti version is unfinished and two horn-like knobs still remain (fig. 27). These are left over from the Roman sculptor's copying technique of taking various critical points in the composition and deploying them as guiding coordinates for the carving of his replica.

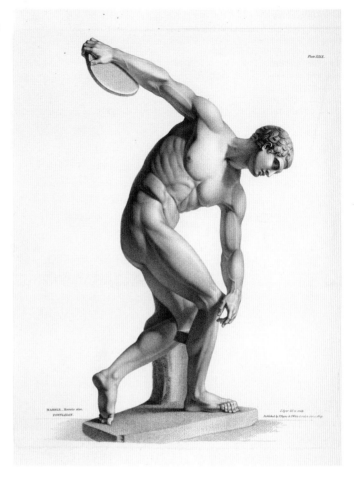

As for the restored head of the Townley Discobolus,
the connoisseurs seem to have accepted the claim that it
was the original. Scholarly dissent over the restoration of
the head first emerged in the first volume of the Society
of Dilettanti's great book, entitled *Specimens of Ancient
Sculpture*, which appeared in 1809, four years after
Townley's death (fig. 28). Richard Payne Knight, a leading
connoisseur of antiquities, declared the head ancient but
alien. He wondered whether it might not be from a version
of the then much admired statue group of two wrestlers
in the Uffizi Palace in Florence. In fact, it belongs to a

42

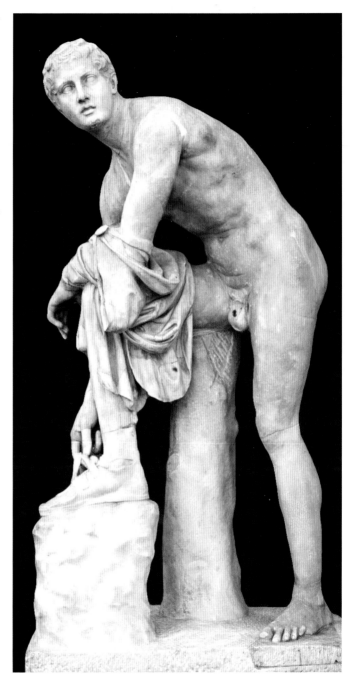

29 Marble copy of the lost bronze original sculpture attributed to 4th-century BC sculptor Lysippus and showing the messenger god Hermes, who bends to adjust the lace of his sandal. It is the head of such a statue that was fitted to the Townley Discobolus. Hadrian's Villa, Tivoli, 2nd century AD. Height 154 cm. NY Carlsberg Glyptothek, Copenhagen.

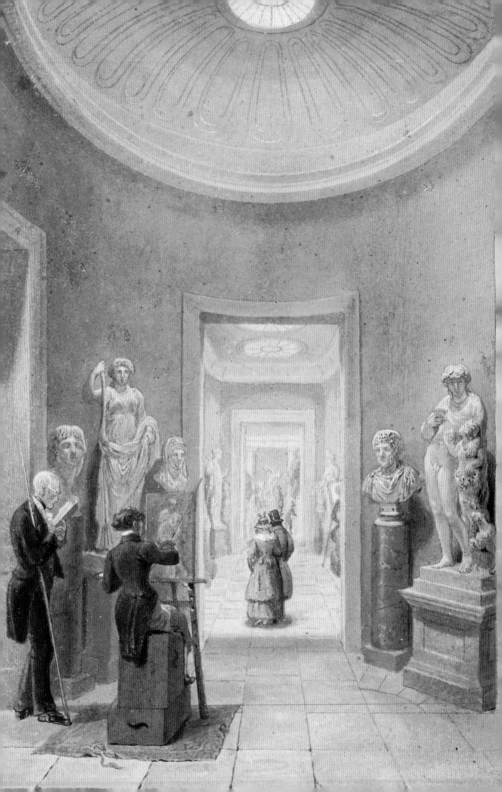

type of Hermes (a messenger god) bending over to tie his sandal, associated with the fourth-century BC sculptor, Lysippus (fig. 29). Lansdowne had acquired from dealer Gavin Hamilton a good Roman marble copy of the Hermes type. Like the Townley Discobolus it had been found in Hadrian's Villa. While such restorations would not be carried out today, we should nevertheless judge them not by present standards but by those of the eighteenth century. Collectors of the day expected their sculptures to be complete, even if this meant a considerable percentage of a given piece being modern. There was also a belief that the Romans, when they copied original Greek works, felt obliged to improve upon them. The eighteenth-century restorers saw themselves as inheritors of this tradition and as producers of what the Pope's antiquary E.Q. Visconti called, *imitations perfectionnées.*

The Discobolus in the British Museum

The discus-thrower was Townley's last major purchase. Upon his death in 1805, the Townley collection of sculpture was acquired by the British Museum and in 1808 went on show in the architect George Saunders' new extension to Montagu House, the mansion in which the Museum collections were first displayed. There it was located at the end of a suite of rooms as a vista-stopper framed between two columns (fig. 30). Townley's Classical sculpture never looked better than it did in the Townley Gallery, but the building stood for less than forty years and was pulled down to make way for Robert Smirke's grander design, the Greek Revival temple of the arts that stands today. Around 1857–8, the Discobolus was photographed by Roger Fenton in the south transept of Smirke's Egyptian Sculpture Gallery (fig. 31). The architectural frame, dramatic lighting, tall base and low viewpoint, give it a monumentality that belies its true scale, which is just over life-size.

The Discobolus was only temporarily placed where Fenton saw it. On close inspection, a block of wood can be seen under the base, a sure sign of its being in transit. Indeed, the statue was only resting on its way to the

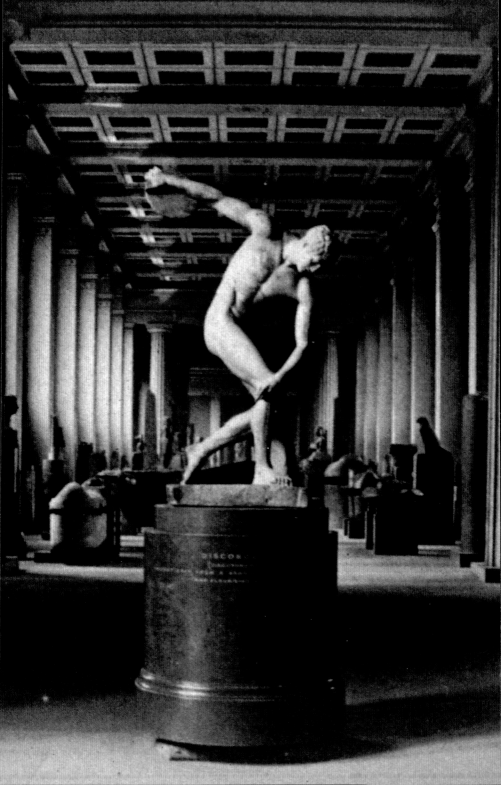

smallest of a suite of rooms projecting westwards that Robert Smirke's brother Sydney designed on a far lesser scale than the grand Egyptian Sculpture Gallery. Just two sculptures, facing each other in alcoves, were to be accommodated in the smallest of these rooms. They were the Townley Discobolus on one side and on the other Townley's semi-nude, life-size Aphrodite. Together they represented exemplars of male and female beauty.

The nineteenth-century arrangement of the Townley Marbles survived largely intact until their evacuation during World War II. Damage from enemy bombing rendered many of the Museum's galleries unfit for immediate use after the war and the majority of Townley's sculptures were to disappear into basement storage. Their absence from public view would have been felt more keenly had they not already fallen in the estimation of many. Although decorative, such heavily restored sculpture was compared unfavourably with the British Museum's collection of original Greek temple and tomb sculpture, such as that from the Parthenon and the Nereid Monument. Only the discus-thrower stood out from the crowd. As a copy of a lost masterpiece of the fifth century BC, it had a status over and above the other Townley Marbles and, besides, there was particular interest in its subject as a representation of ancient athletics.

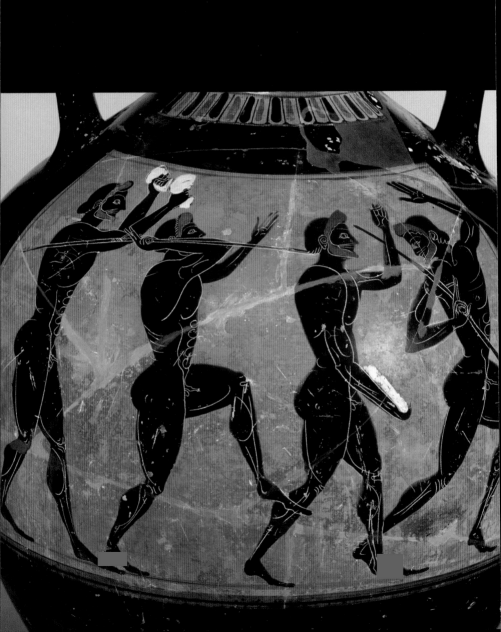

Ancient discus-throwing

The contest in throwing the discus at Olympia and at other games was part of the pentathlon, the five-event competition that also included long jump, javelin, the stadium race on foot and wrestling. All of these events were held in the stadium, where the banked up sides allowed the crowds of spectators to see over the heads of those in front.

Ancient discuses survive in iron, stone and, most commonly, in bronze (fig. 33). They vary greatly in size but average around twenty centimetres in diameter and about two kilos in weight. Most examples come from religious sanctuaries and are often engraved with dedicatory inscriptions and sometimes with outline representations of athletes. According to the ancient author Pausanias (*Periegesis* 19.4), three discuses used in the games were kept in one of the treasuries at Olympia. This may suggest that the competition involved throwing discuses of varying weights. Representations of the discus-thrower in Greek art are many and various. Most numerous are bronze statuettes, scenes on Athenian red-figured painted pottery (fig. 32) and miniature images carved into sealstones.

33 Bronze discus dedicated by the victorious athlete Exoidas to Castor and Pollux, twin sons of Zeus. Greece, 6th century BC. Diameter 16.5 cm; weight 1.25 kg. British Museum.

The popularity of Myron's discus-thrower is attested by Roman writers on art and the fact that more than twenty marble copies survive, whole or in part. Besides these full scale replicas, there is a striking large bronze statuette in Munich (fig. 34). Reproducing Myron's composition, it is

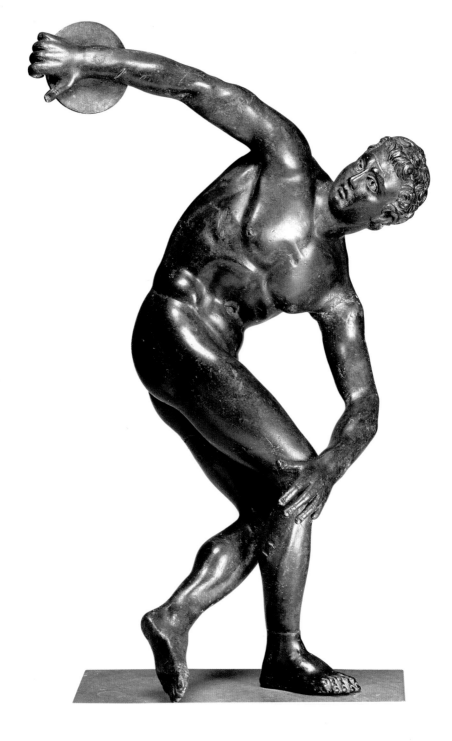

34 Opposite Bronze statuette of Myron's discus-thrower. 3rd–2nd century BC. Height 24 cm. Glyptothek, Munich.

35 Below Robert Garrett throwing the discus at the 1896 summer Olympics in Greece. The athlete poses with the head forward in the manner of the newly restored Townley Discobolus.

free of the tree stump that was necessarily introduced into the large marble copies in order to strengthen their ankles and lower legs. The head, however, is entirely different from Myron's mid fifth-century BC type, and the silvered eyes blaze with an intensity that belongs to the later Hellenistic or Roman periods of Greek art.

The great variety of pose pictured in Greek and Roman art makes it impossible to say whether, like today's athletes the ancient discus-thrower stood with his back to the direction of the throw. It is equally unclear whether, as today, the athlete did a half spin or whether he simply twisted his body round with feet rooted to the spot.

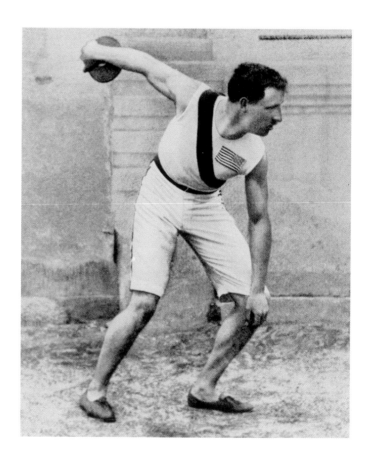

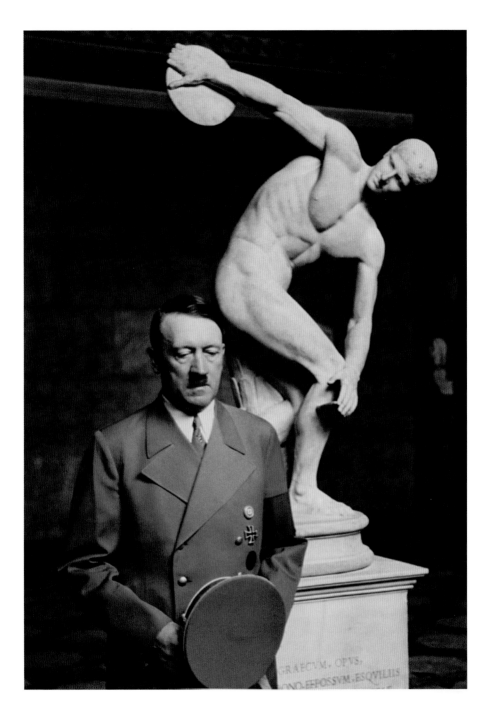

The Nazi Olympics and the Ration Book Games

1936, the year of the Nazi Olympics, saw several representations of ancient discus-throwing exhibited in *Sport der Hellenen*, an exhibition in the Berlin Museum. There were vase paintings and bronze statuettes showing a great variety of pose and ways of holding the discus. Foremost among them was the twenty-four centimetre high statuette in bronze from the Munich Glyptothek (fig. 34), which reproduced the pose of Myron's statue more commonly found in copies in marble. Two years later, this bronze was to be joined in Munich by the Lancellotti Discobolus itself. It was bought from the Lancellotti family on 18 May 1938 for the equivalent of a reported 327,000 US dollars.

In Leni Riefenstahl's documentary film of the 1936 Berlin Olympics, *Olympia* (1938), the opening sequence features the German decathlete Erwin Huber emerging from the Lancellotti Discobolus. This and other introductory passages of the film promote Nazi Germany as the modern embodiment of the Classical past. The camera moves over the ruins of the Acropolis of Athens and encounters in its path famous Classical sculpture. Soon the poetic landscape of old Greece is populated by living athletes in skimpy loin cloths. The boundary between marble and flesh is deliberately blurred by oiling statue and living athlete alike. The whole treatment of Riefenstahl's subject seems calculated to promote Germany as a latter day Nordic Greece.

Huber's metamorphosis from marble into flesh is impressive when viewed as a moving image, but it is interesting to observe how a clip from the film reveals the awkward contortion of the athlete's living body as he tries to force his torso into a frontal plane, while the legs remain in profile. We see what ancient commentators had in mind when they criticized the pose of Myron's bronze as somewhat forced.

After the War, the Americans presiding over the

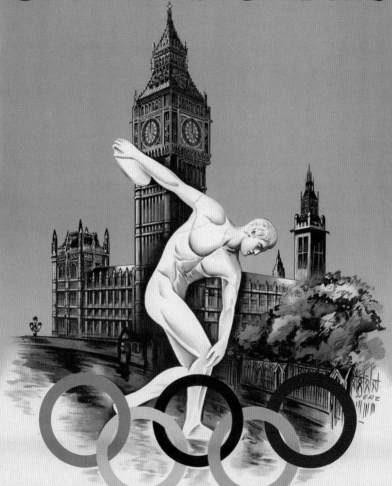

OLYMPIC GAMES

29 JULY 1948 14 AUGUST
LONDON

Designed by HEROS PUBLICITY STUDIOS LTD.

Printed in Great Britain by McCORQUODALE & CO. LTD., LONDON, S.E.1

return of artworks looted by the Nazis insisted that the Lancellotti sculpture be repatriated to Rome. German academics pointed out that it had been purchased, but the American Military Government and the liberated Italian intelligentsia were adamant. It would go back, not to the Lancellotti family, but to the Museo Nazionale in Rome. It arrived in November 1948 and went on show in the second national exhibition of the works of recovered art.

In the summer of that very same year London had held its 'ration book' or 'austerity Olympics'. As part of the publicity for the 1948 London Games, a transport poster was commissioned from the designer Walter Herz, the chief artist at Heros Publicity Studios Ltd. The firm was based at 37 Museum Street, very close to the British Museum. In the poster, we see the Townley Discobolus hovering over the Olympic insignia with the Palace of Westminster behind. The hands of the dial on Big Ben are stopped at four o'clock, the hour of the start of the Games. The message is clear and its symbolic value could not be more different from the Nazi appropriation of the Lancellotti Discobolus for propaganda purposes. The Houses of Parliament represent the world's oldest continuous democracy; the Discobolus betokens the world's first democracy and the idea of political and intellectual freedom traditionally associated with the ancient Greeks. The Olympic rings reference the Games in a world restored to peace.

A comparison may be drawn between the 1948 repatriation of looted artworks and that of 1815 when, after the Battle of Waterloo, British Foreign Secretary Castlereigh led the mission to Paris that would dismantle the Louvre. The Italian marbles, including the Pope's own discobolus, reached Rome in January 1816. This was the year in which Parliament decided to purchase the Elgin Marbles and thus boosted London's claim to be a new Athens, in deliberate contrast with Paris' now discredited self-assertion as a new Rome.

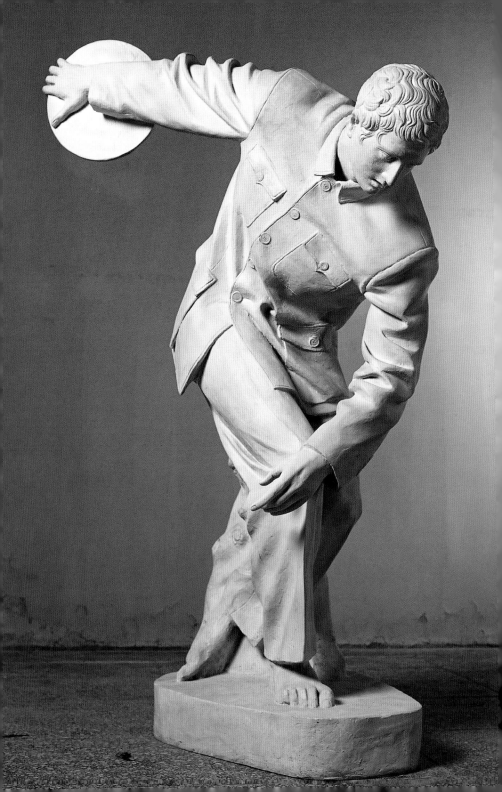

The Discobolus now

Today the Discobolus remains a powerful image in western culture but also in the Far East. The Beijing Olympics in 2008 saw the head of Chairman Mao (1893–1976) replaced on the ten-yuan banknote by an image of the Lancellotti Discobolus. Already, however, in 1998, the Chinese sculptor Sui Jianguo (born 1956) had begun to experiment with the plaster cast of a discobolus that had reached Beijing before the cultural revolution, dressing it in a Mao suit (fig. 38). Clothed in the Chinese tunic-style suit, Jianguo's discobolus becomes a metaphor for the intellectual and artistic constraints of communist-era China. This curiously beautiful image is rivalled in visual irony and intellectual impact by another of Jianguo's interpretations where, dressing the discobolus in a business suit, the sculptor reproduces it in a manner reminiscent of Chinese mass production (fig. 39).

In 2008, in Shanghai and Hong Kong, the Townley Discobolus itself was exhibited as part of an exhibition about the ancient Olympics. This exhibition brought the Discobolus to the attention of many thousands of people who would not otherwise have seen it. It afterwards became the star piece in an international touring exhibition colloquially known as 'The Greek Body Beautiful'. (Its official title is *The Human Body in Greek Art and Society*.) Such exposure to new spectators increases the fame of the statue which is arguably today the best known life-size sculpture to come down to us from antiquity. To judge from such modern responses to it as those featured in the pages that follow, the discus-thrower remains a powerful image for contemporary consumers and artists alike.

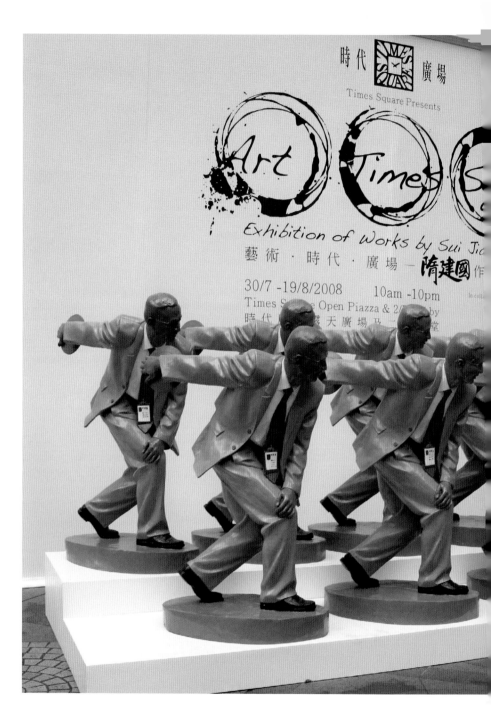

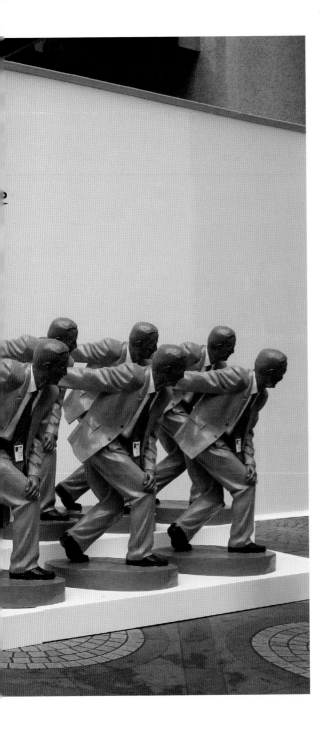

39 A discobolus
for the modern
age, replicated in a
strikingly dramatic
installation by
sculptor Sui Jianguo,
in Times Square,
Hong Kong, 2008.

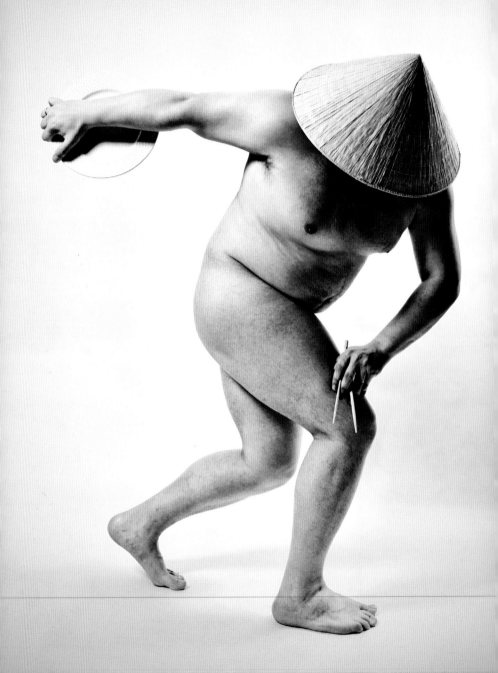

**40 Opposite
Performance artist
Marius Aksijonaitis
as the Discobolus of
Beijing.**

**41 Below Discobolus
of Africa. Digital art
by Quim Abella Ojeda,
2010.**

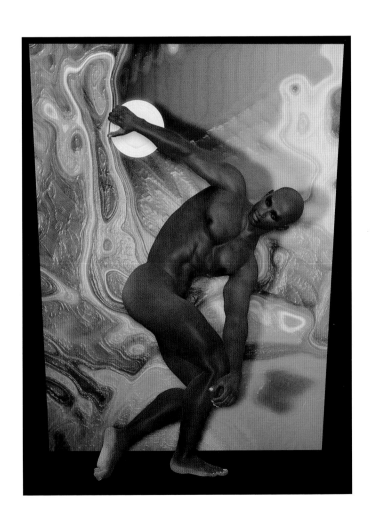

Summary

As befits the artistic and intellectual context of the golden age of ancient Athens, the Discobolus is a cerebral attempt at defining male beauty in an action figure that has features in common with the Canon, and which must have had a great influence on Polyclitus (see page 14). The Doryphorus was that sculptor's answer to the bravura performance of his older contemporary and school fellow Myron, and was designed to set absolute rules for the measurement of perfect beauty. The genre of action figures was rather old fashioned by the time Polyclitus came to create his Canon, and the sculptor therefore chose a pose that was less dynamic but not, as we have seen, altogether static. Needless, to say Polyclitus' Canon would be overtaken by new challengers. Among them, the sculptor Lysippus. In the fourth century BC his system of proportion yielded figures of slender grace and flowing elegance, seemingly absent in the work of Polyclitus.

Polyclitus' rivalry did not obscure the fame of Myron's Discobolus and in the Roman period it enjoyed a popularity that was probably equal to that of the Canon.

In the modern era Myron's masterpiece has eclipsed the celebrity of Polyclitus' Doryphorus. If only as a representation of a sporting event, the discus-thrower is perhaps the single statue to survive from antiquity that may be deemed instantly recognizable. Since its creation in the fifth century BC, it has fascinated, challenged and inspired and continues to do so today. The inventive imagery of modern art plays upon its fame and in so doing renders it more famous still.

Meanwhile the Townley Discobolus continues upon its world tour as a cultural ambassador for the ancient Greeks and a universal image of humanity idealized.

Further reading

The sculpture

As a prominent fifth-century BC Greek sculptor, Myron and his best known work are well represented in most general histories of Greek sculpture. For a recent fresh and in-depth study of the Discobolus see H. Thliveri, 'The discobolus of Myron, narrative appeal and three-dimensionality', in F. MacFarlane and C. Morgan (eds.) *Exploring Ancient Sculpture: Essays in Honour of Geoffrey Waywell*, Institute of Classical Studies (London 2010) 7–70. See *also* A. Anguissola, 'Roman copies of Myron's discobolus', *Journal of Roman Archaeology* 18 (2005) 317–335.

Discovery, restoration and reception

The modern history of the Townley Discobolus has been pieced together here from original letters and drawings in the British Museum's Central Archive and the library of the Department of Greece and Rome. An earlier excellent discussion of some of the same documents is S. Howard, 'Some eighteenth-century restorations of Myron's discobolos', *Journal of the Warburg and Courtauld Institutes* 25/3–4 (1962) 330–334. The Townley correspondence has been transcribed and published by I. Bignamini and C. Hornsby, *Digging and Dealing in Eighteenth-Century Rome*, 2 volumes (New Haven and London 2010). On the restoration of the various discoboli, including Townley's, see W. Geominy and A. Basile, 'Der Diskobol Lancellotti und seine Ergänzungen' in M. Kunze et al. *Wiedererstandene Antike, Ergänzungen antiker Kunstwerke seit der Renaissance* (Munich 2003) 229–242. For further discussion on the Landsdowne collection of sculpture see E. Angelicoussis, 'Diomedes and Diskobolus,' *Apollo Magazine* (May 2011)

Ancient commentaries

For the ancient literary sources relating to the life and work of Myron, see those collected by J.J. Pollitt, *The Art of Ancient Greece, Sources and Documents* (Cambridge, revised edition 1990) 48–52. For Naukydes and the Discophorus, see 79–80. For interpretation of critical terms used by the ancient authors (such as *rhythmos* and *symmetria*) see J.J. Pollitt, *The Ancient View of Greek Art Criticism, History, Technology* (New Haven and London 1974).

Ancient discus-throwing

For the Greek discus see S. Miller, *Ancient Greek Athletics* (New Haven and London 2004) 60–63.

Political and cultural reception

There is a growing literature on the Nazi appropriation of the Lancellotti Discobolus. For a concise account see R. Wünsche, 'Zur Geschichte der Glyptothek zwischen 1830 und 1948' in *Glyptothek München 1830–1980* (Exhibition catalogue Munich 1980) 87–89. For a detailed account see H. Bernett, 'Der Diskuswerfer des Myron: Geschicke eines Idols in Wechselfällen der Politik', *Stadion, International Journal of the History of Sport* 17 (1991) 27–51. For the Nazi Olympics see Michael Mackenzie, 'From Athens to Berlin: The 1936 Olympics

and Leni Riefenstahl's Olympia', *Critical Enquiry*, Chicago 29 (Winter 2003) 302–336.

For the 1948 London Games see J. Hampton and S. Coe, *The Austerity Olympics, When the Games came to London in 1948* (London 2008).

For the cultural reception of the Discobolus as Greek Body see, A. Leoussi, *Nationalism and Classicism: The Classical Body as National Symbol in Nineteenth-Century England and France* (London 1998); see also 'Myths of Ancestry', *Nations and Nationalism* 7 (2001) 467–486.

Picture credits

Every effort has been made to trace the copyright holders of the images reproduced in this book. All British Museum photographs are © The Trustees of the British Museum.

1 British Museum GR 1805,0703.43 (Sculpture 250)
2 Frankfurt Liebieghaus 147; © akg-images/Eric Lessing
3 Vatican Museums, Rome BS225; © akg-images/Cameraphoto
4 British Museum GR 1859,0301.109
5 Accademia Galleries, Venice; © akg-images/Cameraphoto
6 Munich University, Germany; © akg-images
7 Museo Nazionale, Rome; from the Esquiline Hill; former collection Massimo-Lancellotti
8 British Museum GR 1805,0703.43 (Sculpture 250)
9 British Museum GR 1882,0422.1 (Sculpture 1753)
10 British Museum PD 1995,0506.8
11 Burnley Borough Council, Townley Hall Art Gallery and Museums; © The Bridgeman Art Library
12 British Museum GR 2010,5006.1689
13 British Musem GR 2010,5006.1688
14 British Museum GR 2010,5006.1687
15 British Museum GR 2010,5006.1686
16 British Museum MS TY 7/599
17 British Museum photograph
18 British Museum GR 1805,0703.43 (Sculpture 250)
19 British Museum GR 2010,5006.1805
20 British Museum GR 2010,5006.90
21–3 British Museum GR 1805,0703.43 (Sculpture 250)
24 Vatican Museums, Rome; © akg-images
25 British Museum GR 2010,5006.1803
26 British Museum GR 2010,5006.91
27 Museo Nazionale, Rome; from the Esquiline Hill; former collection Massimo-Lancellotti
28 Illustration from *Specimens of Ancient Sculpture*, Vol. 1, plate XXIX; British Museum photograph
29 NY Carlsberg Glyptotek, Copenhagen 2798
30 British Museum PD 1862,0614.632
31 British Museum photograph
32 British Museum GR 1842,0314.1 (Vase B134)
33 British Museum GR 1898,0716.3
34 and 36 Munich Glyptothek; Staatliche Antikensammlungen und Glyptothek München, photo: Renate Kühling
35 © Getty Images
37 British Museum GR 2007,5006.1/ International Olympic Committee © IOC
38 and 39 © Sui Jianguo
40 © Marius Aksijonaitis
41 © Quim Abella Ojeda.